The Norman Rockwell Poster Book

Edited by Michael Schau

WATSON-GUPTILL PUBLICATIONS, NEW YORK

found, nothing is gained by pretending in books that things in our country are different from what they are.

"Having gone on record publicly with this claim of the right of an honest portrayer of human life to give us his report, even if it sickens us, I think I have the right to make the same claim for another honest portrayer of human life even if his report cheers and comforts us.

"Just at present the one is up on the see-saw of aesthetic fashion and the other is down. This is, I think, an especial reason for calling the attention of Americans to Norman Rockwell. . . . If he had painted in the mid-Victorian period of hush-hush about the ugly and ignoble aspects of human life, a comment on what he gives us should, perhaps, have contained a reminder that—the traditional European reproach to Emerson—he does not look at death, failure, defeat. But we have in these last decades supped deep of portrayals of frustration and defeat. Such portrayals give but one aspect of real life. Another aspect has the right to our recognition. It is true that, in our country, minorities suffer from savagely unjust discriminations, that there are shocking inequalities of opportunity which cause widespread human misery. But in our America there are also—so familiar that a portrayal of them gives to millions the pleasure of recognition—uncountable homes, warm with love and trust, and with thankfulness for the shelter, in the very midst of the typhoon of human struggle, which such homes give to those who live in them.

"No one can deny that in many tenement houses the poor are ground down by poverty, disease or racial injustice into the dreadfulness of wishing, being hurt themselves, to hurt others weaker than they. Our hearts have been frozen by many a powerful book-presentation of this literal but partial truth. Norman Rockwell reminds us (we must not forget that he is as accurately true to the literal fact, and as partial), that in these same tenement houses in which the safe return of a soldier son—insignificant droplet in the military ocean—sets off an explosion of joy magnificent in its power and purity.

"In a period when wormwood and vinegar are the fashionable flavorings, it is genuine originality for Rockwell to dip his brush into the honey-pot of lovableness and zest in living."

Scores of factors account for Norman Rockwell's pre-eminence in America's heart. The Rockwell pictures are a popular history of our country, so it is appropriate this year more than ever that we celebrate the artist who so affectionately and enthusiastically celebrates America.

THE POSTERS

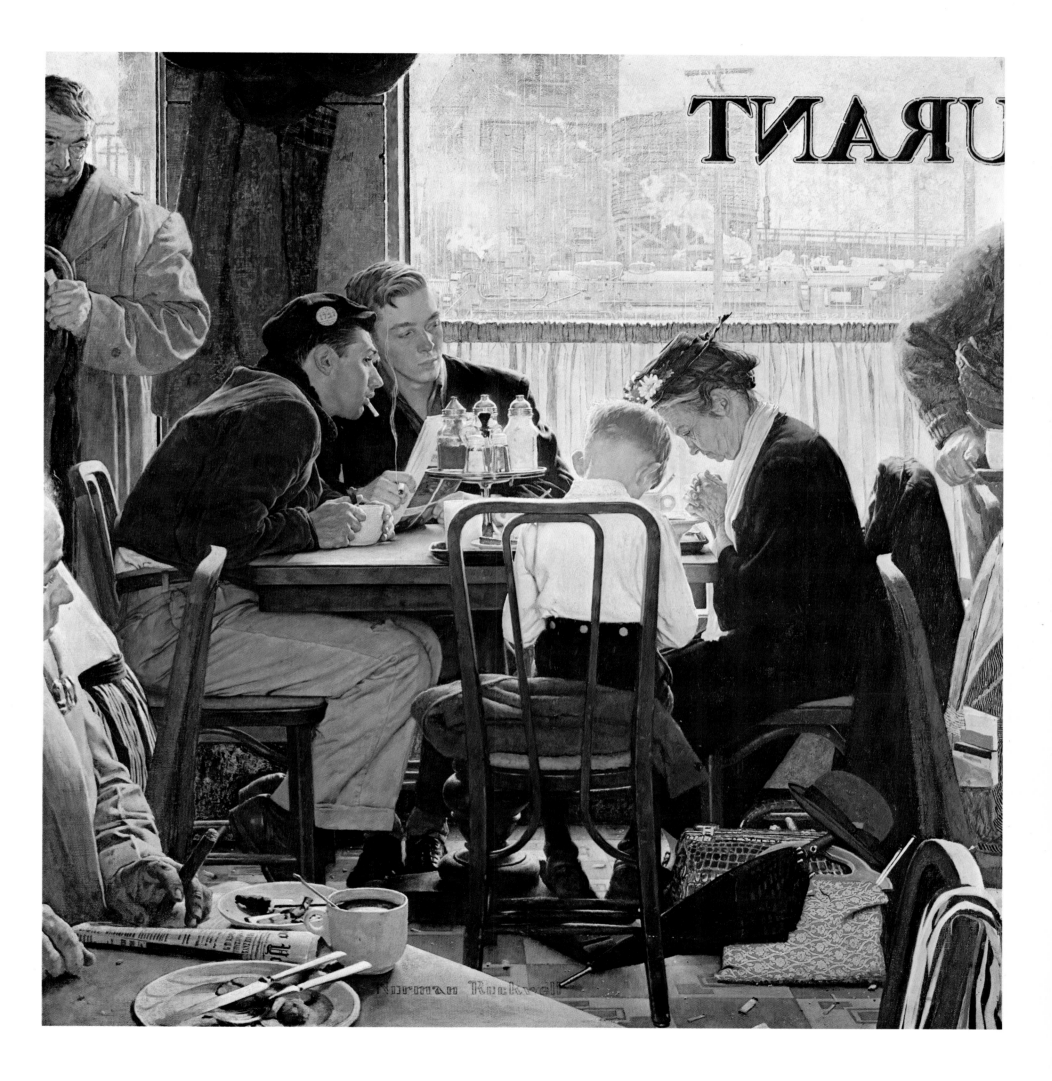

SAYING GRACE. Painting for cover of *The Saturday Evening Post,* November 24, 1954.

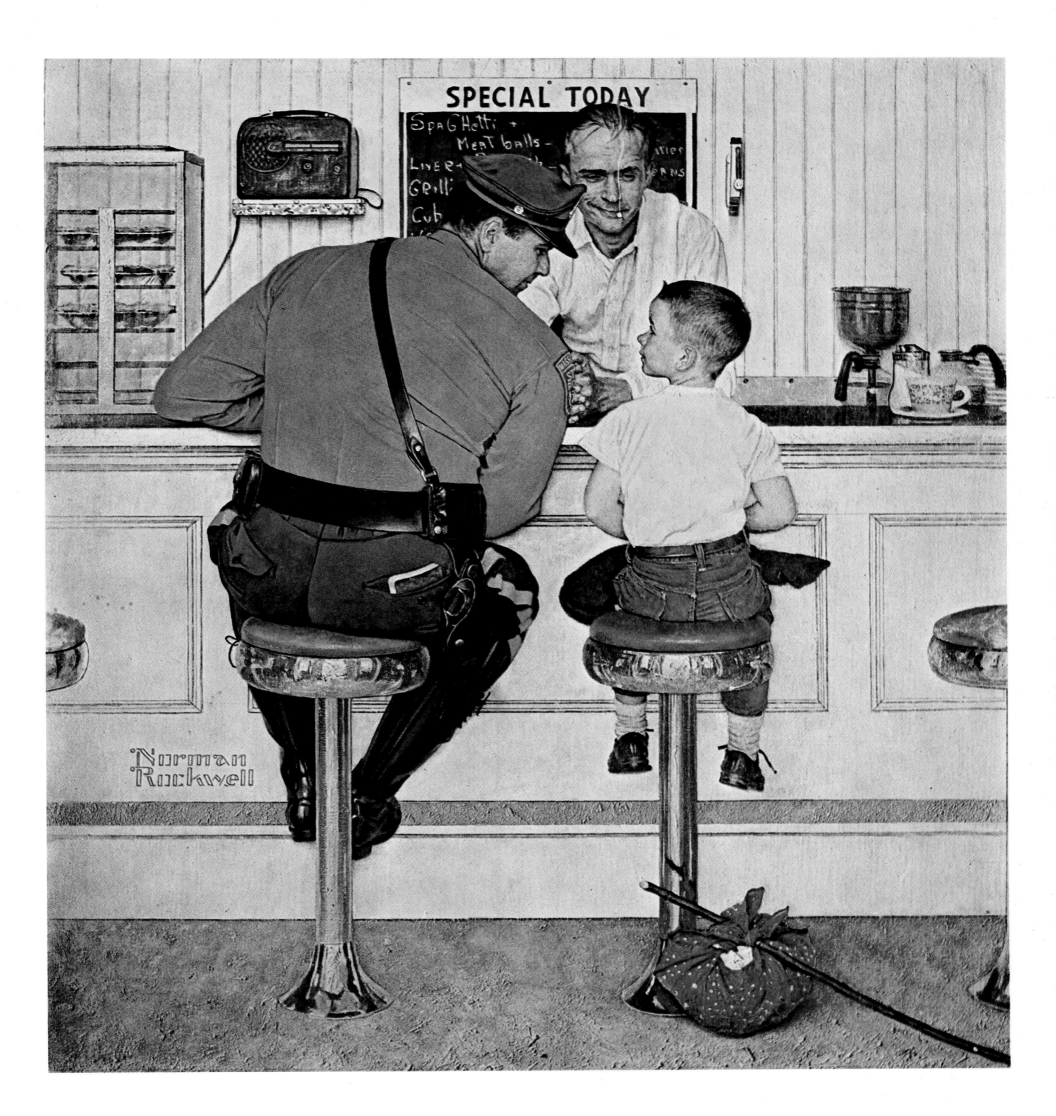

THE RUNAWAY. Painting for cover of *The Saturday Evening Post,* September 20, 1958.

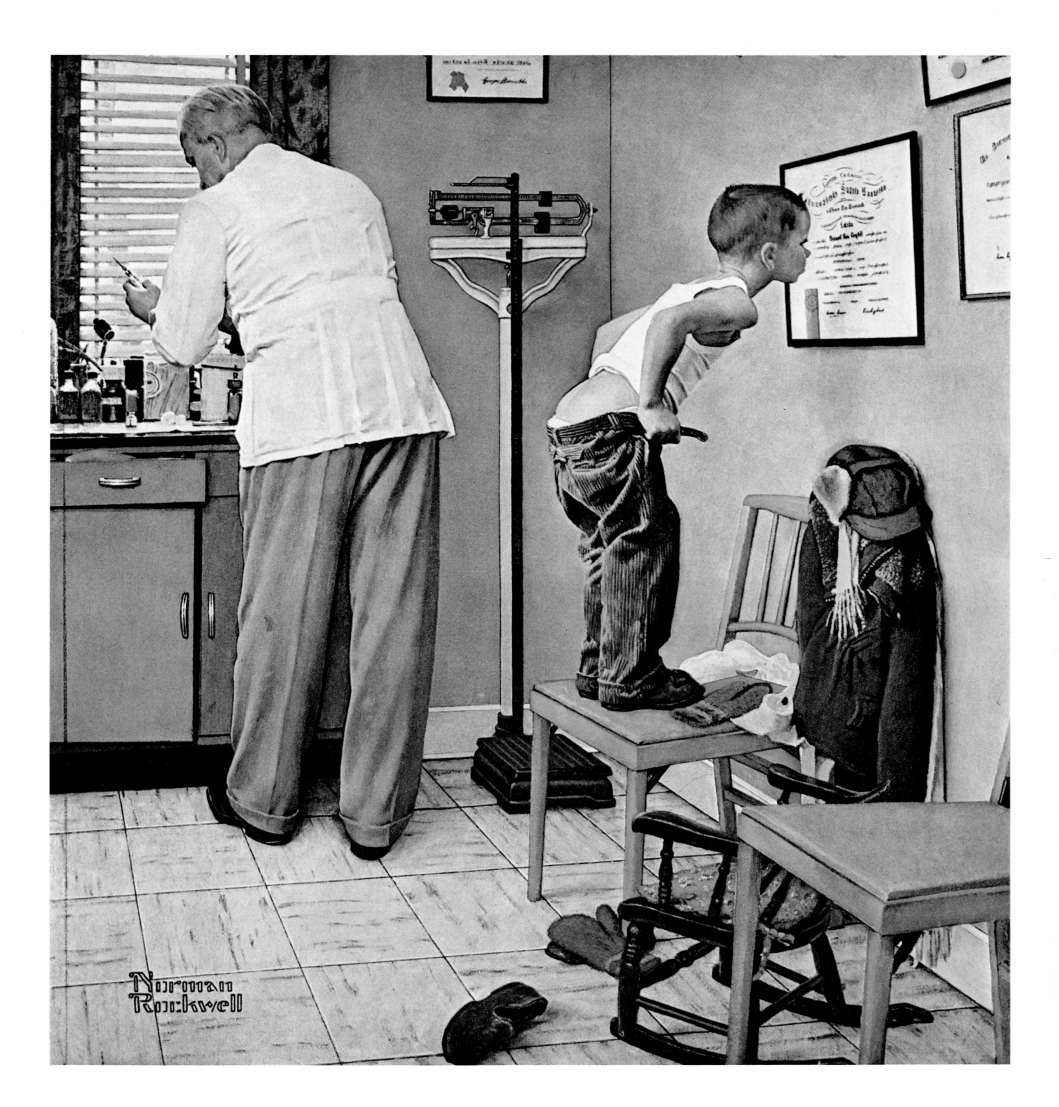

AT THE DOCTOR'S OFFICE. Painting for cover of *The Saturday Evening Post,* March 15, 1958.

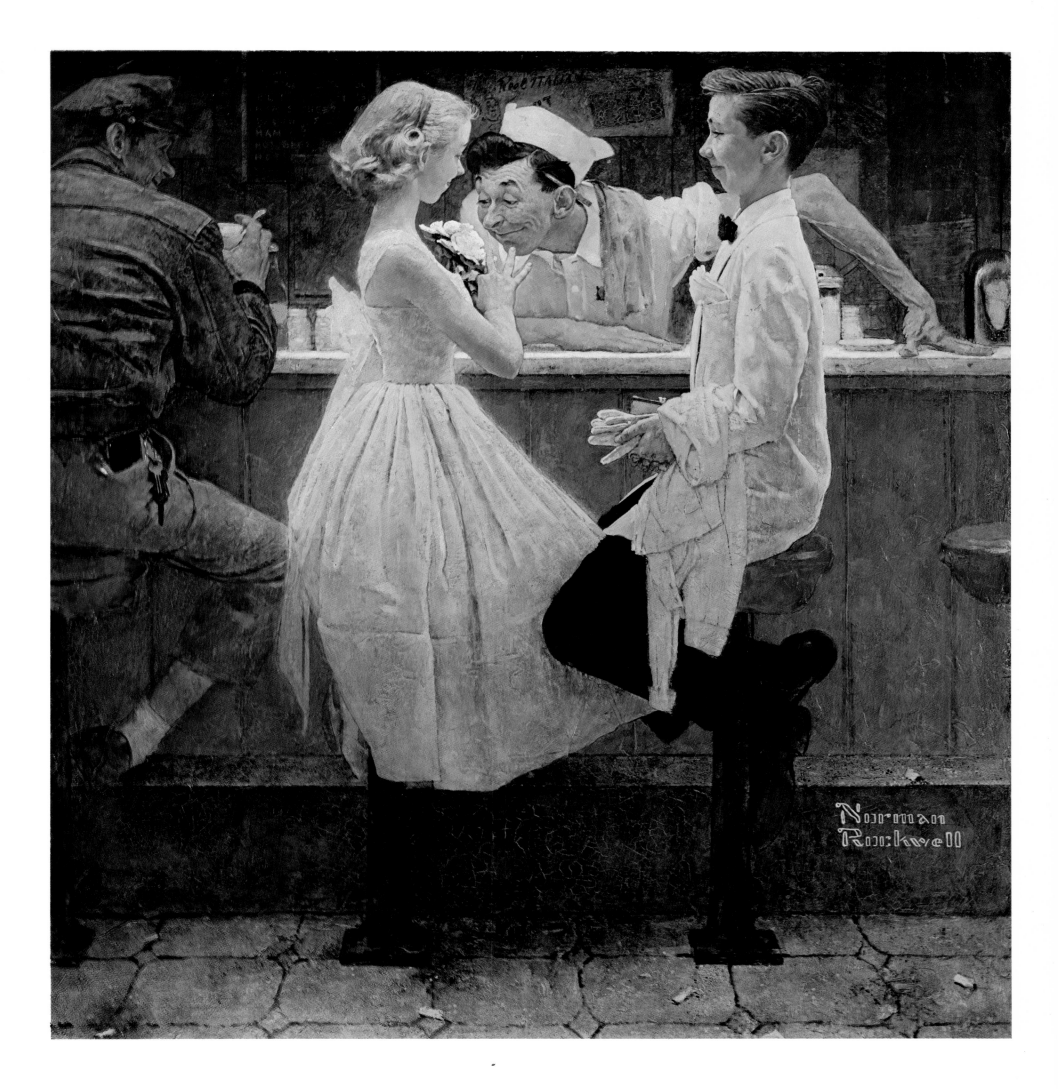

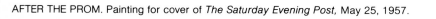
AFTER THE PROM. Painting for cover of *The Saturday Evening Post,* May 25, 1957.

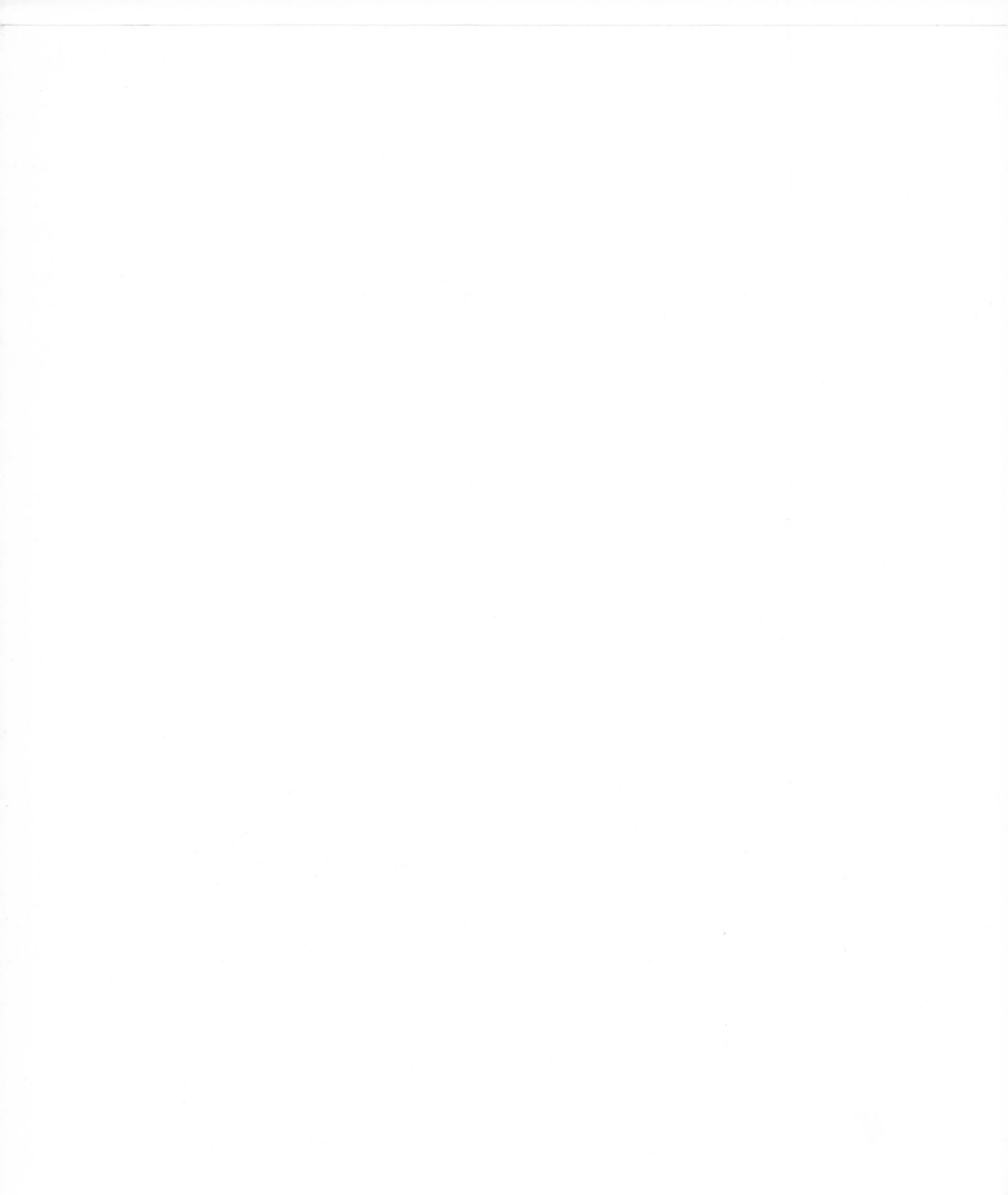

SPRING. Painting for four seasons calendar, 1958. Reproduced by permission of
and copyright by Brown & Bigelow, a division of Standard Packaging, St. Paul, Minnesota.

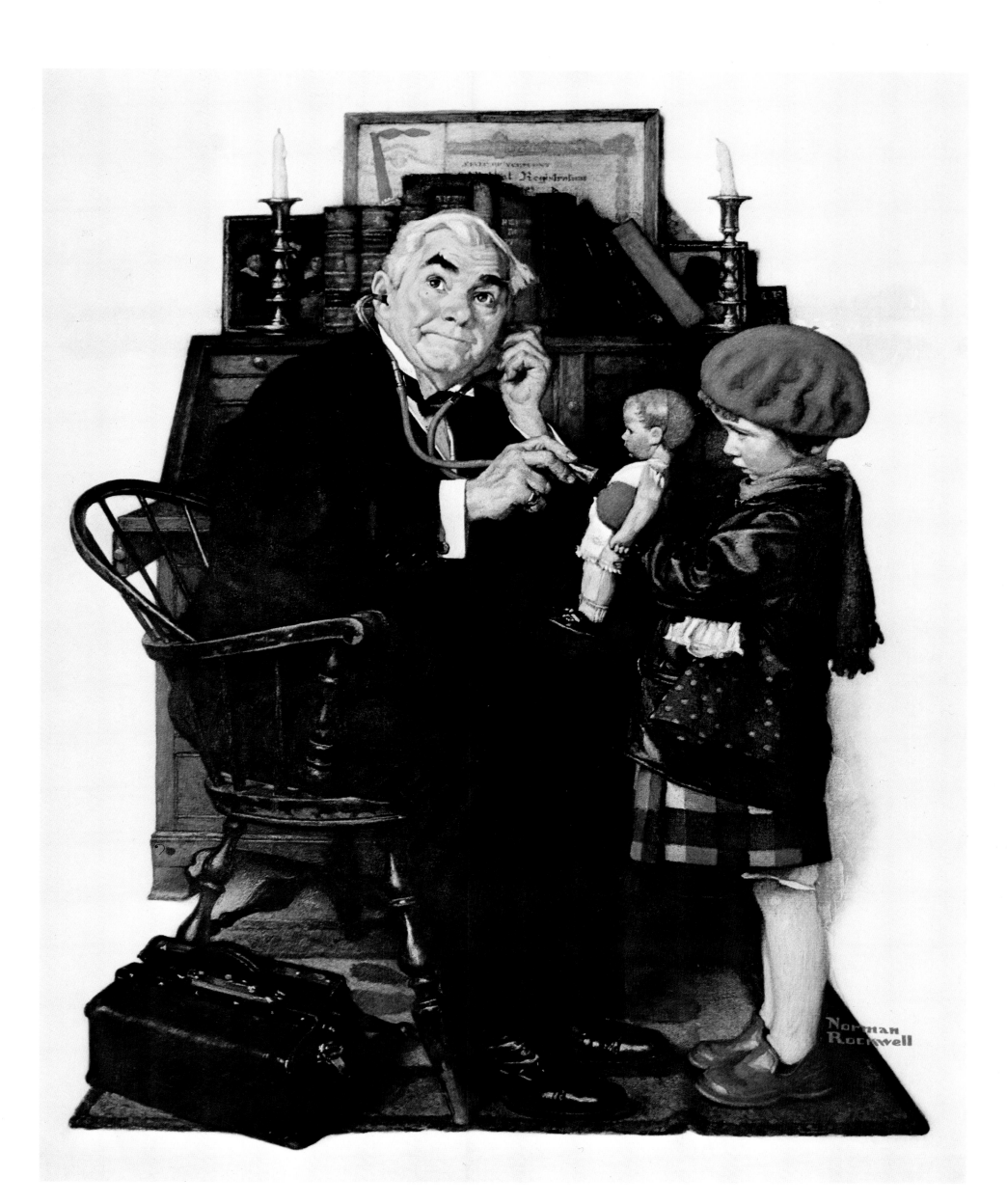

DOCTOR AND DOLL. Painting for cover of *The Saturday Evening Post*, March 9, 1929.

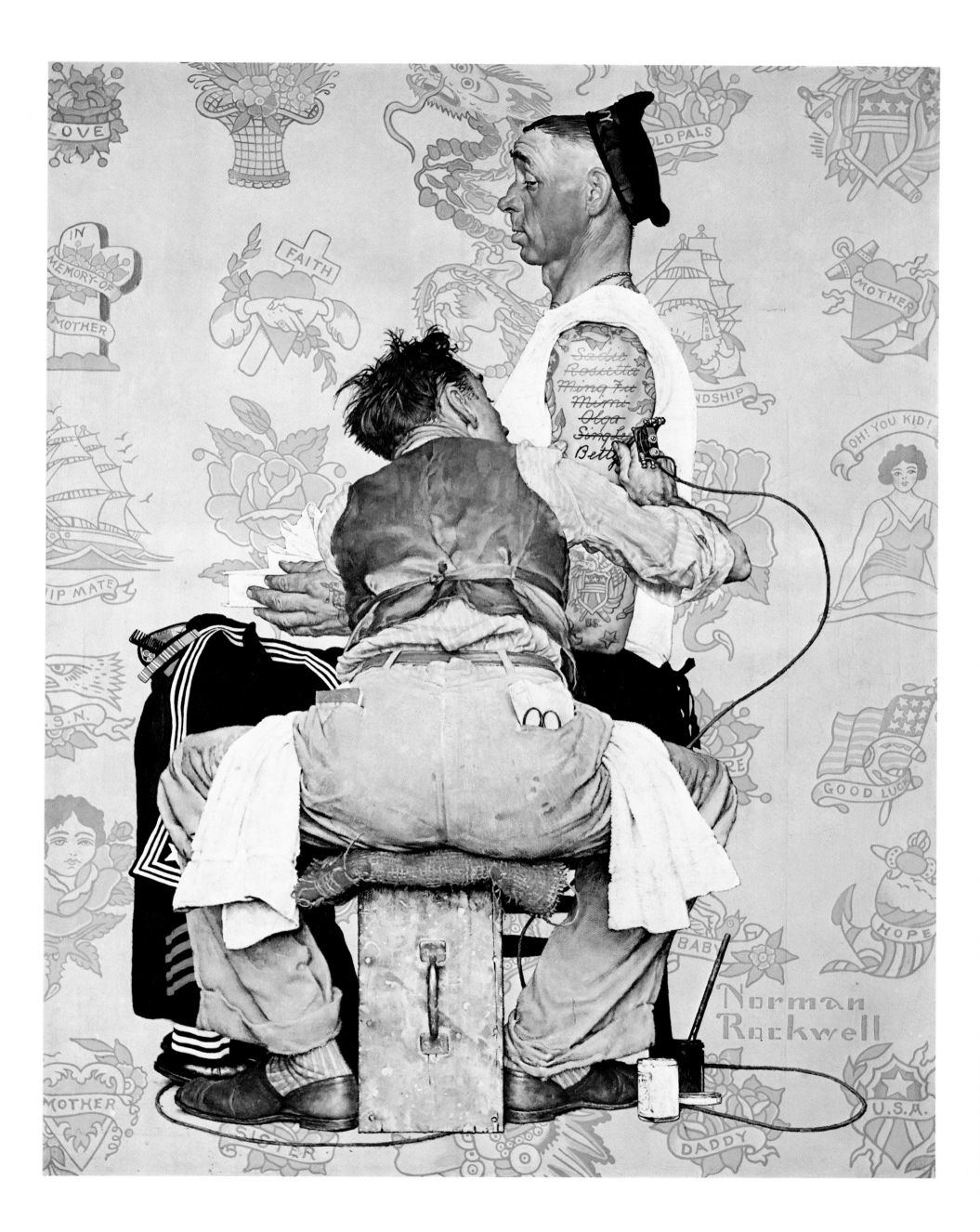

THE TATOOIST. Painting for cover of *The Saturday Evening Post,* March 4, 1944.

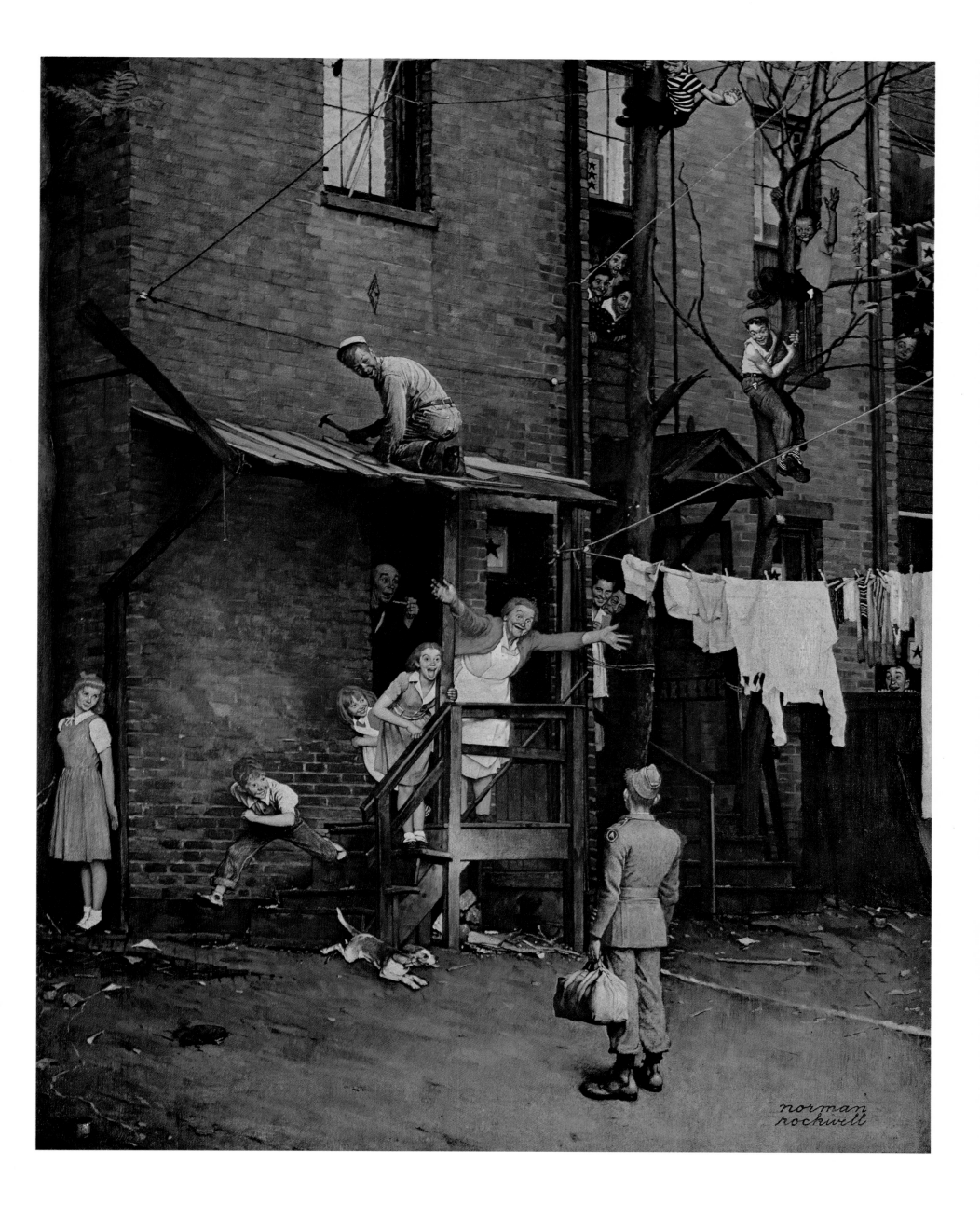

HOMECOMING G.I. Painting for cover of *The Saturday Evening Post,* May 26, 1945.

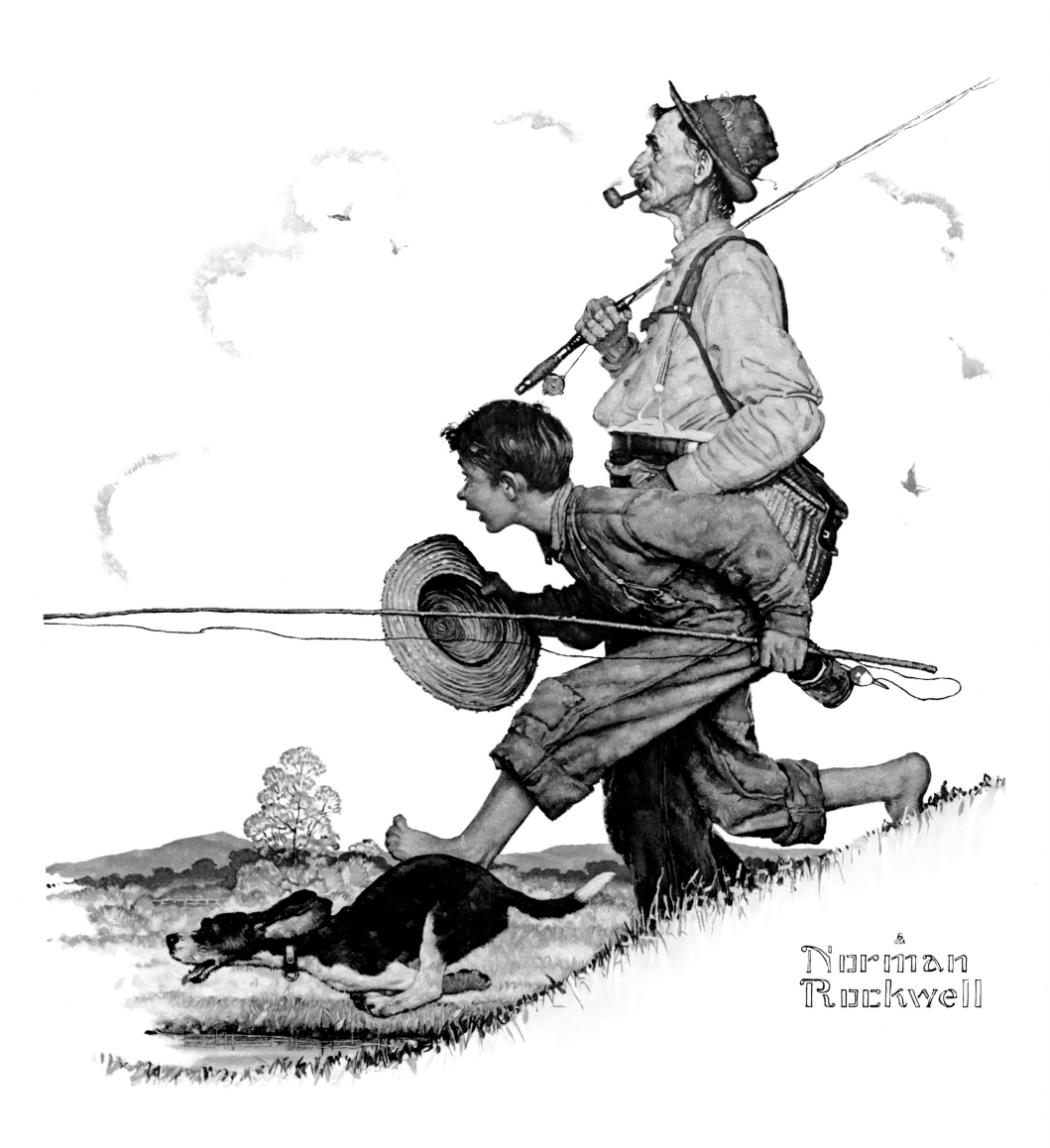

GOING FISHING (SUMMER). Painting for four seasons calendar, 1948. Reproduced by permission of and copyright by Brown & Bigelow, a division of Standard Packaging, St. Paul, Minnesota.

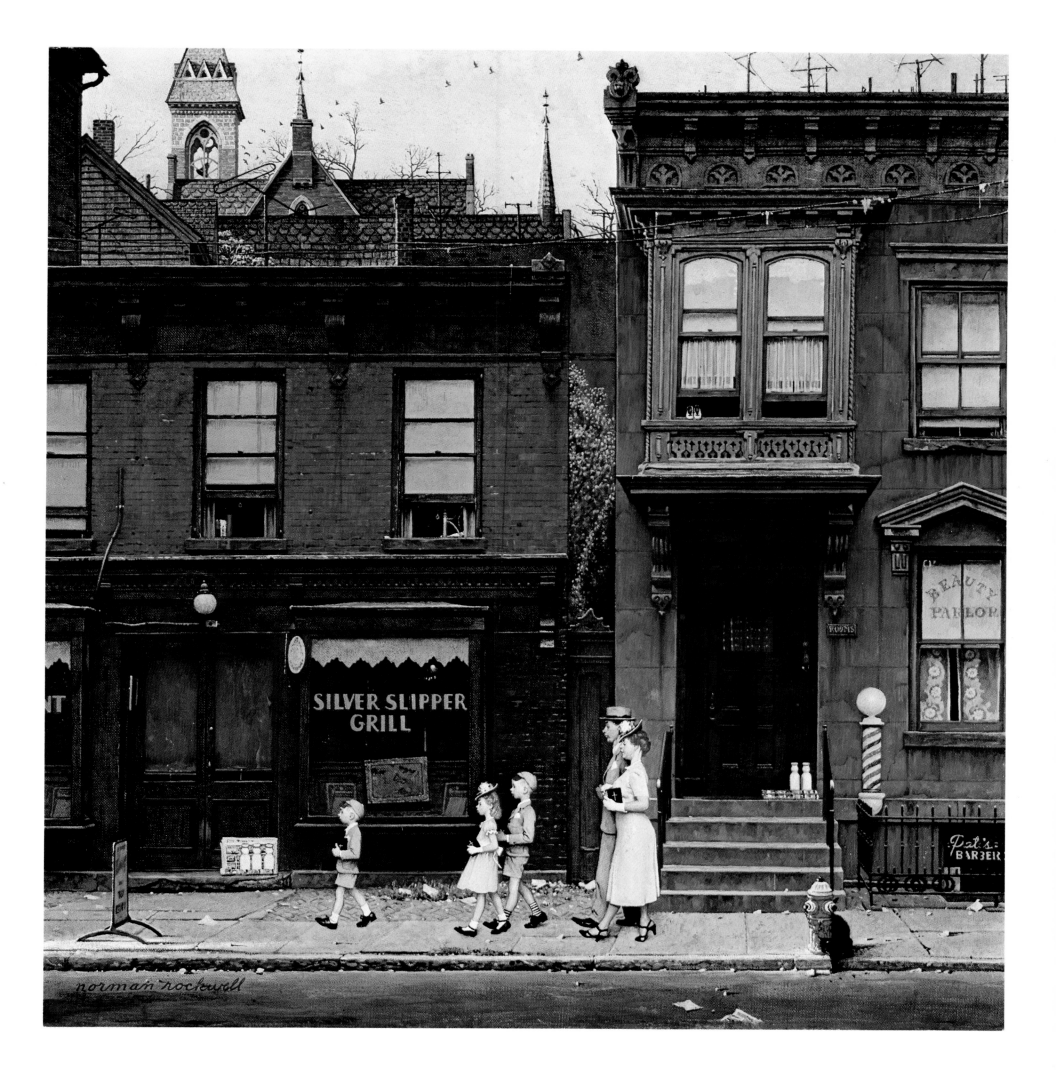

WALKING TO CHURCH. Painting for cover of *The Saturday Evening Post,* April 4, 1953.

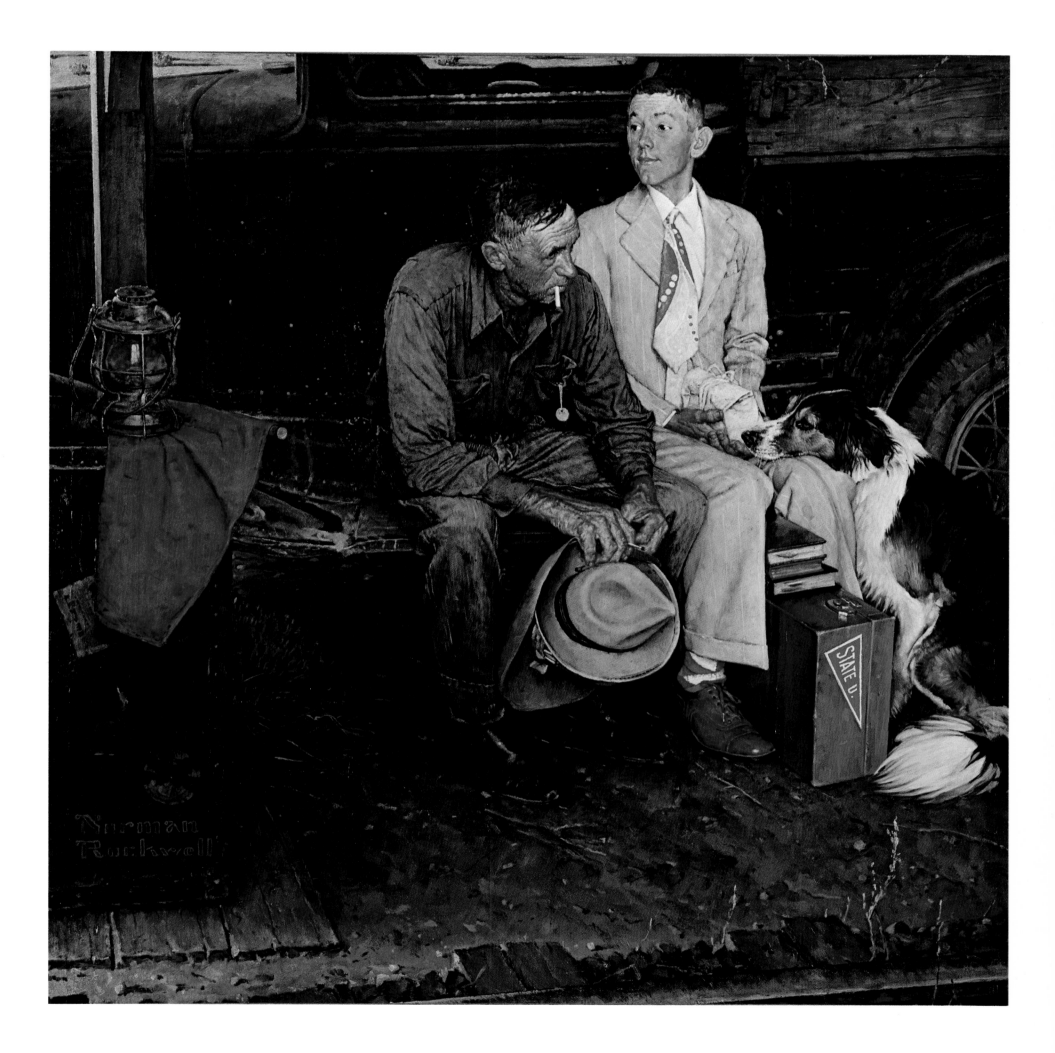

BREAKING HOME TIES. Painting for cover of *The Saturday Evening Post*, September 25, 1954.

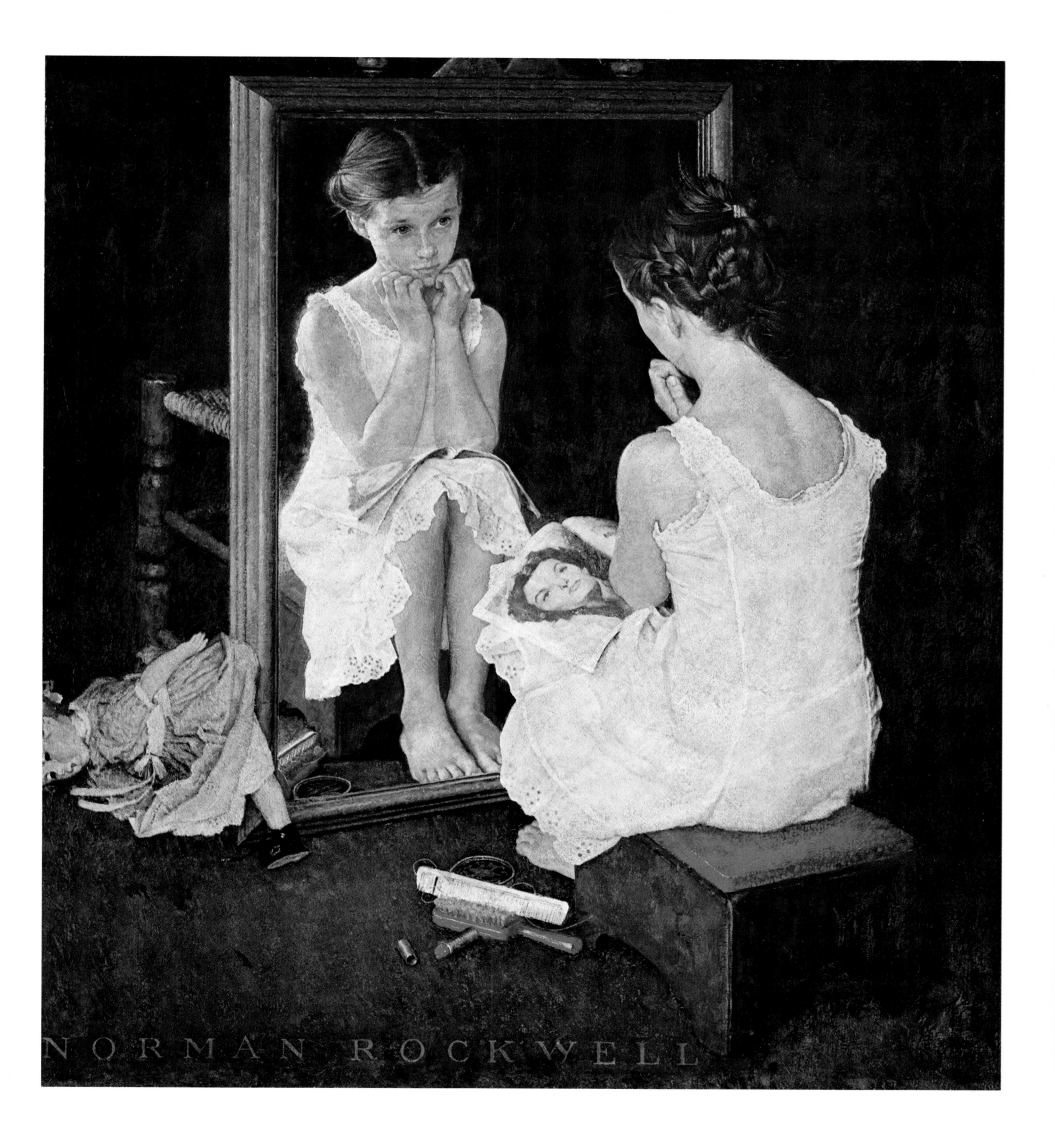

GIRL AT THE MIRROR. Painting for cover of *The Saturday Evening Post*, March 6, 1954.

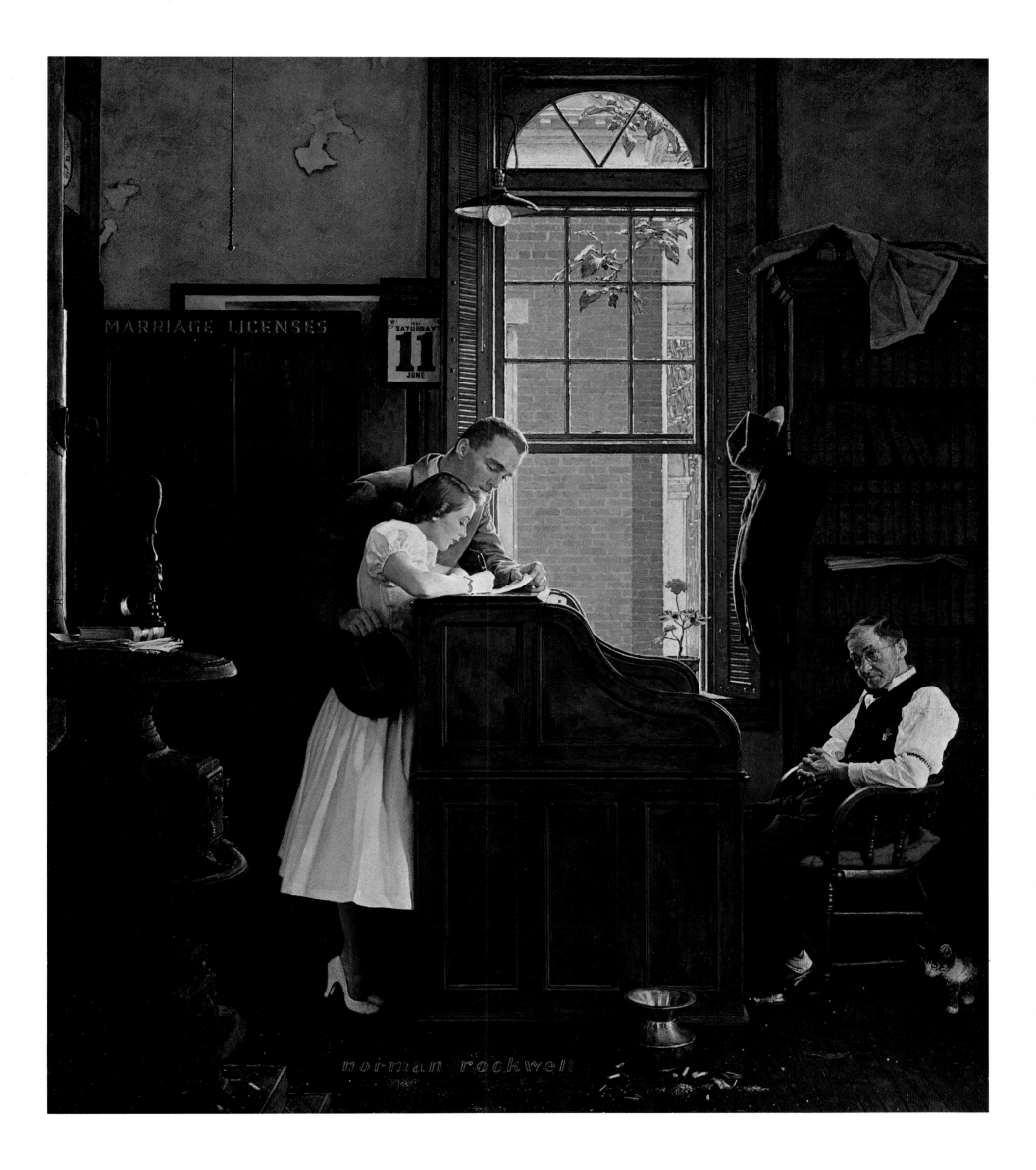

MARRIAGE LICENSE. Painting for cover of *The Saturday Evening Post,* June 11, 1955.

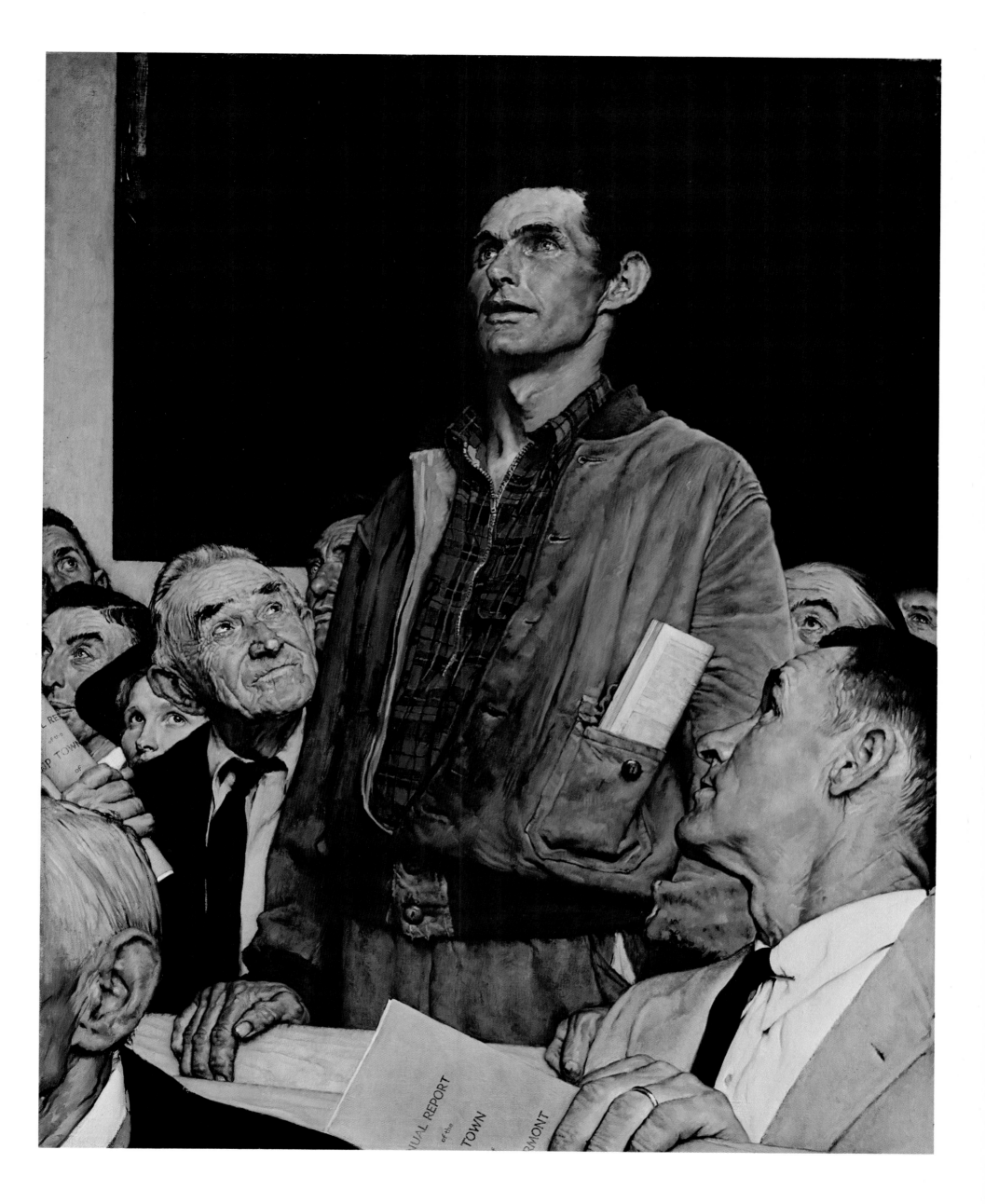

FREEDOM OF SPEECH. From the Four Freedoms series. Originally painted for *The Saturday Evening Post*, 1943.

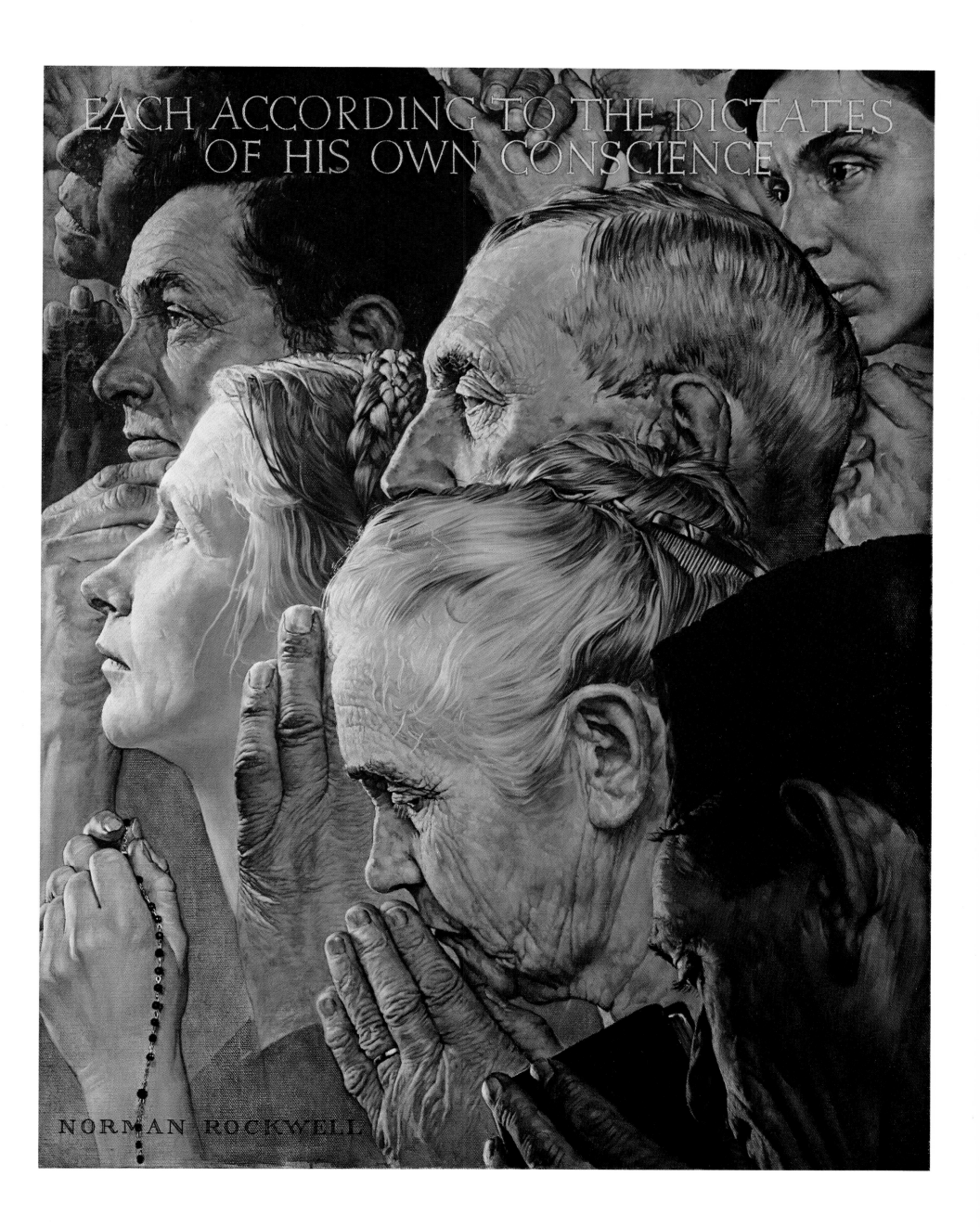

FREEDOM OF WORSHIP. From the Four Freedoms series. Originally painted for *The Saturday Evening Post*, 1943.

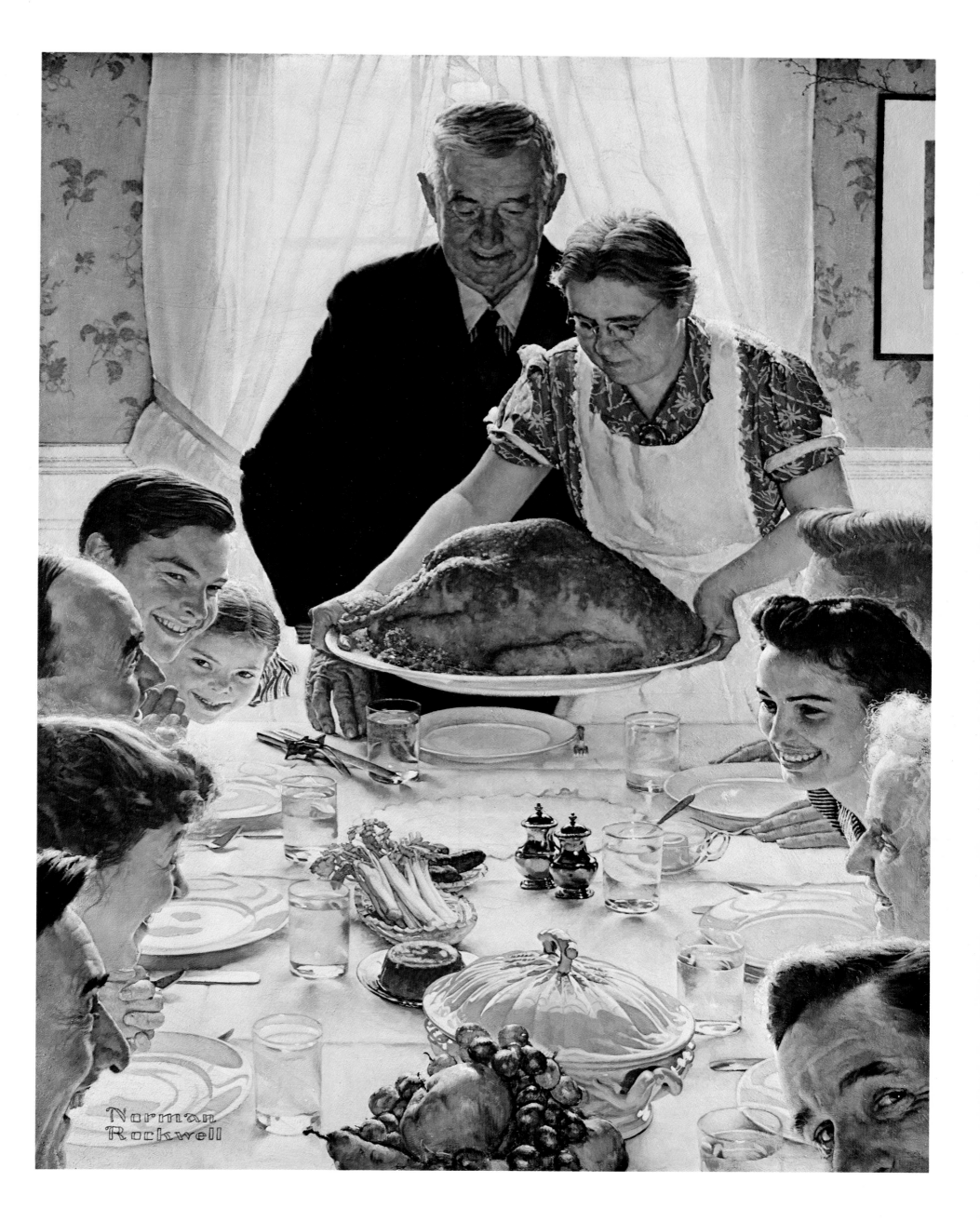

FREEDOM FROM WANT. From the Four Freedoms series. Originally painted for *The Saturday Evening Post*, 1943.

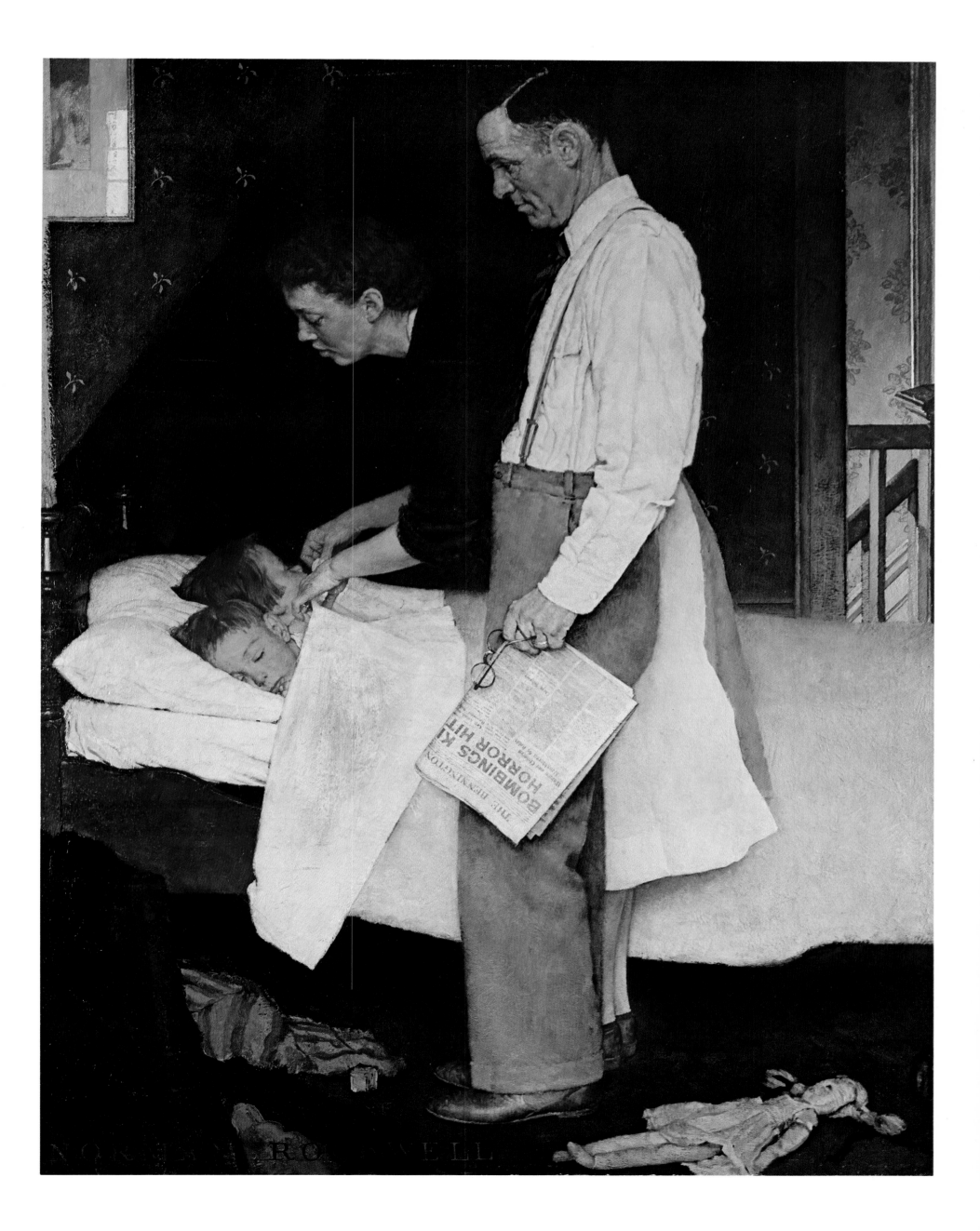

FREEDOM FROM FEAR. From the Four Freedoms series. Originally painted for *The Saturday Evening Post*, 1943.

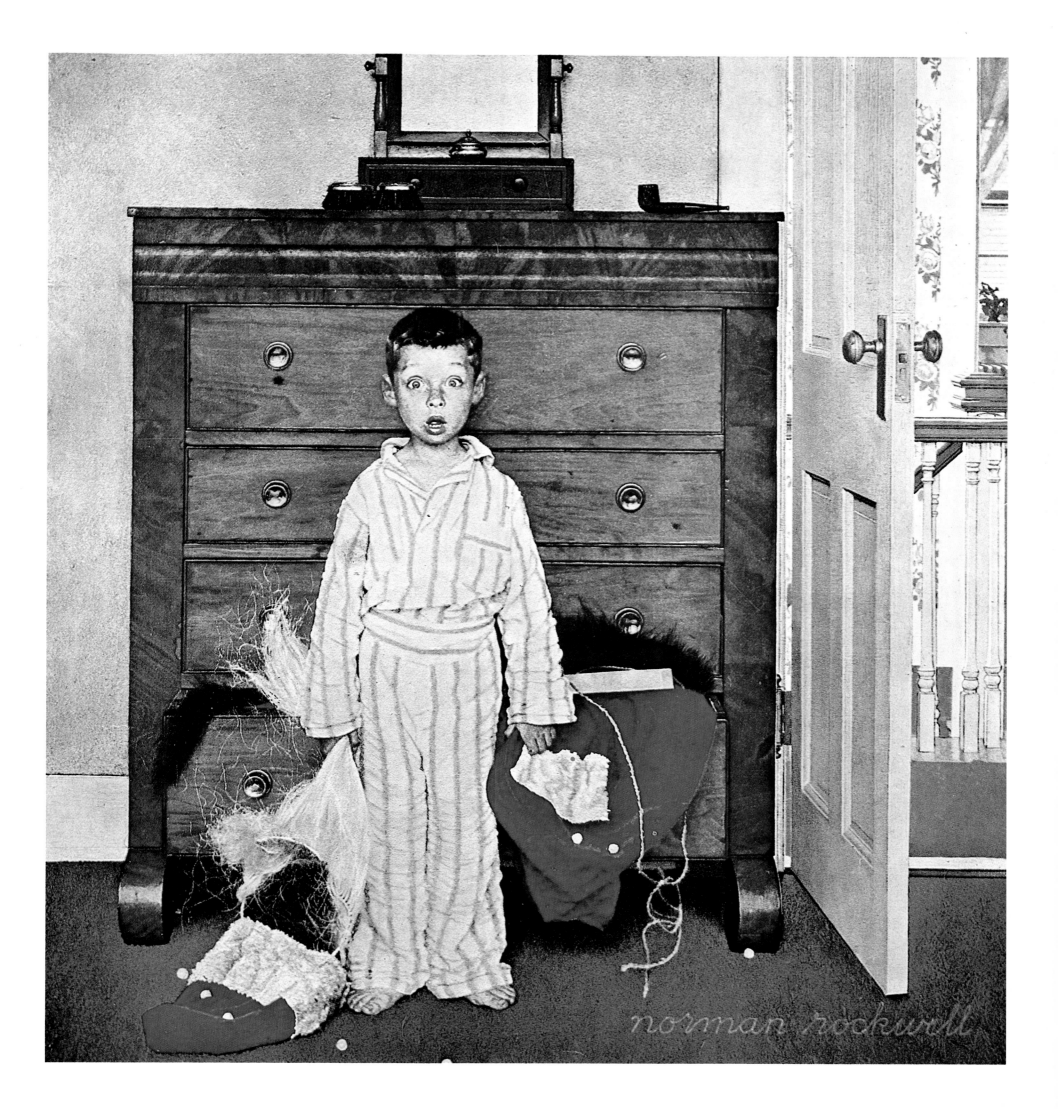

DISCOVERING SANTA. Painting for cover of *The Saturday Evening Post*, December 29, 1956.

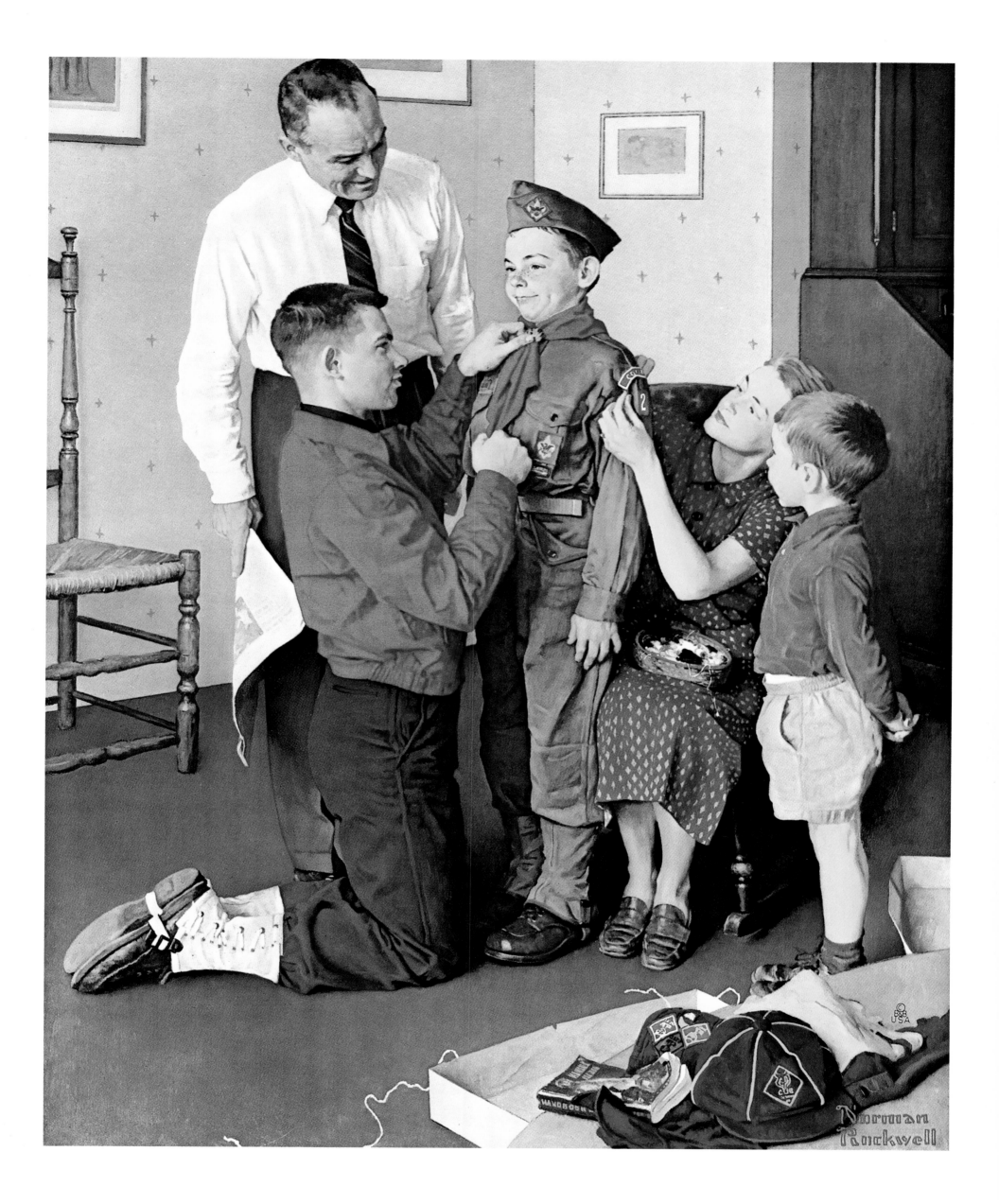

MIGHTY PROUD. Painting for Boy Scouts of America, 1946. Reproduced by permission of
and copyright by Brown & Bigelow, a division of Standard Packaging, St. Paul, Minnesota.

(back cover)
AUTUMN. Painting for four seasons calendar, 1958. Reproduced by permission of
and copyright by Brown & Bigelow, a division of Standard Packaging, St. Paul, Minnesota.